How to Dra

Insects

In Simple Steps

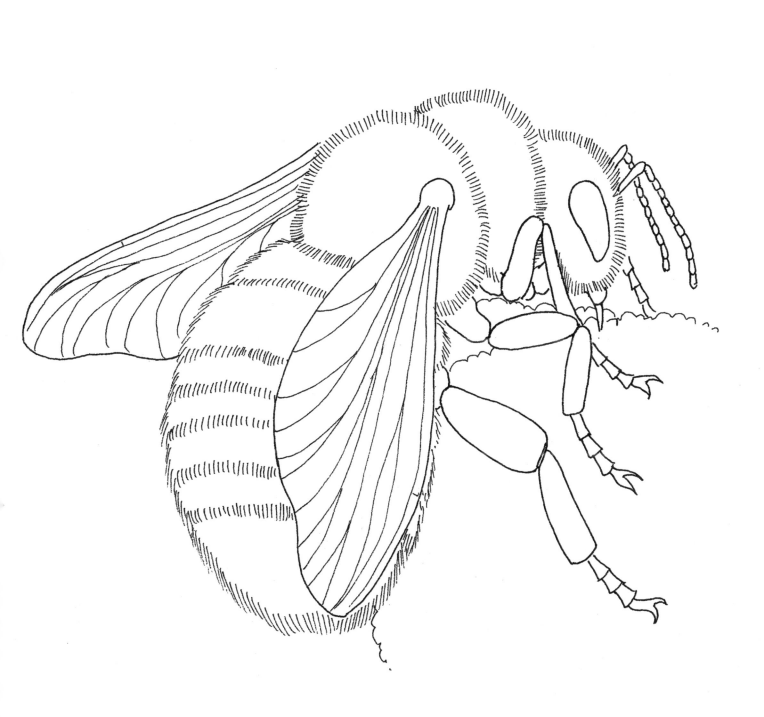

First published in Great Britain 2013

Search Press Limited
Wellwood, North Farm Road,
Tunbridge Wells, Kent TN2 3DR

ISBN: 978-1-84448-447-8

Printed in Malaysia

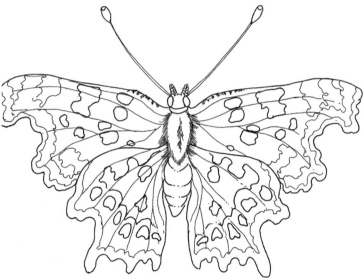

Dedication

For the bumblebee

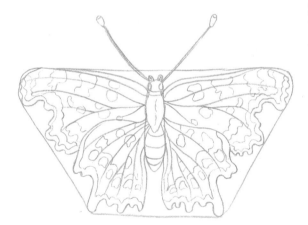

How to Draw
Insects

In Simple Steps

Dandi Palmer

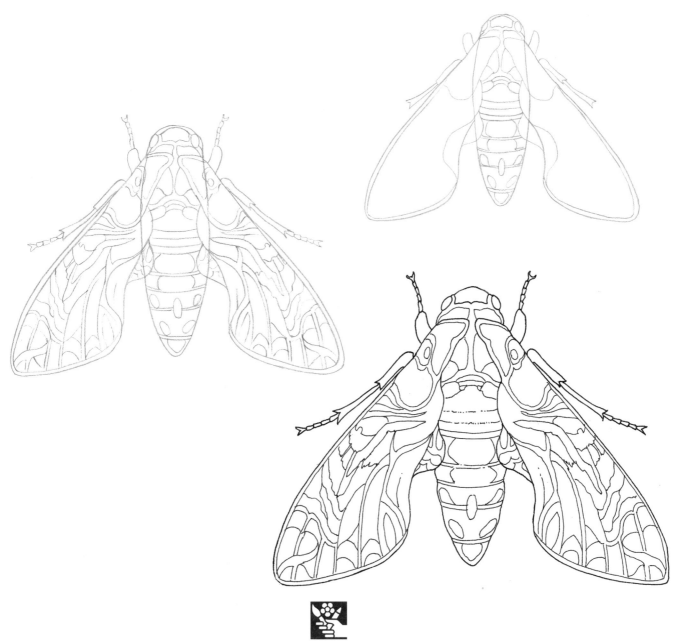

Search Press

Introduction

Prepare to be astonished, not only by the weird appearance, diversity and anatomy of insects when you start drawing them, but also by some facts about these strange creatures. If you weighed all of the earth's insects they would be far heavier than the weight of the whole human race. For each one of us there are millions of them and many have awesome abilities. For example, there is nothing quite like the life cycle of the butterfly; that colourful redeemer of the voracious caterpillar which spins a cocoon to give it magical birth. Then there are those that play a big role in our environment - bees, for example. They are major pollinators of flowering plants and without them many of these plants would die. There are others that we regard as pests. If you are amongst those who are convinced that insects are as monstrous as the creatures in Nausicaä of the Valley of the Wind, the 1984 animated film by Hayao Miyazaki, nothing will persuade you otherwise. Fortunately, few grow any larger than the Goliath beetle, owing to the limitations of an unyielding carapace.

When drawing your insect, bear in mind that its anatomy is totally unlike that of a mammal or reptile. Rather than a skeleton on the inside, an insect has an external skeleton which needs to be shed to allow growth, and it has six legs. There are three parts to the body: the head, the thorax and the abdomen. The flying insects' legs sprout from below the thorax and they are balanced by wings or wing cases.

In the first stage of each drawing the initial guidelines are sketched in brown pencil, then mauve is used to progressively build up the image. If you sketch your insect in pencil, when you are satisfied with the result the key lines can be drawn in using a fine felt tipped pen and the pencil lines erased. Coloured pencils have been used for the final images here, although you may prefer to use another medium.

The insect family includes the wonderful, amazing and totally unexpected, so before you next decide to tread on that bug, take a closer look instead and wonder at its jewelled wings or brightly striped, segmented abdomen – not too closely if it is a hornet or a fire ant of course.

Happy Drawing!

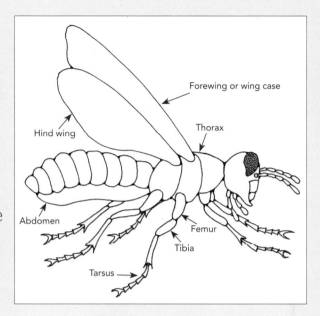

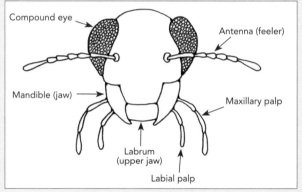

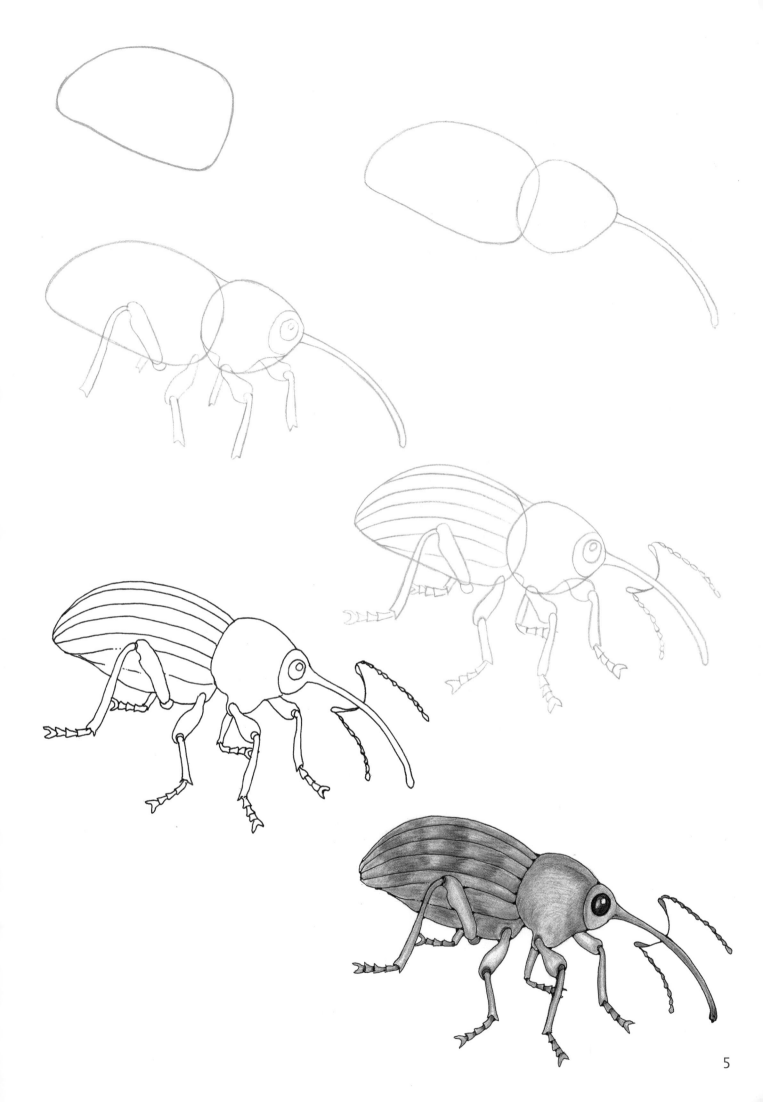

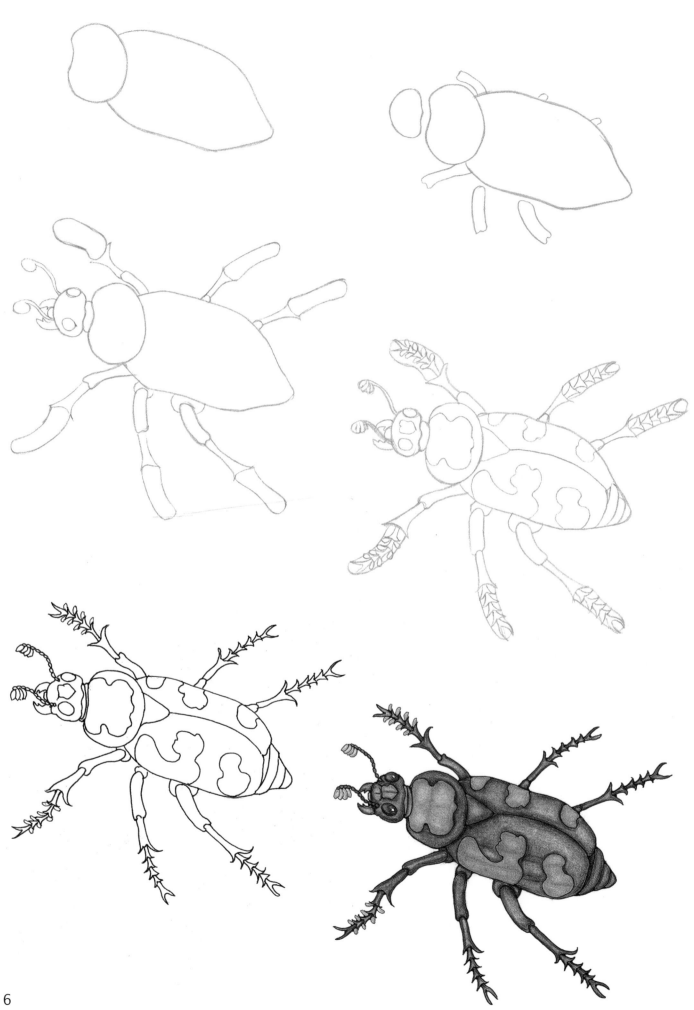

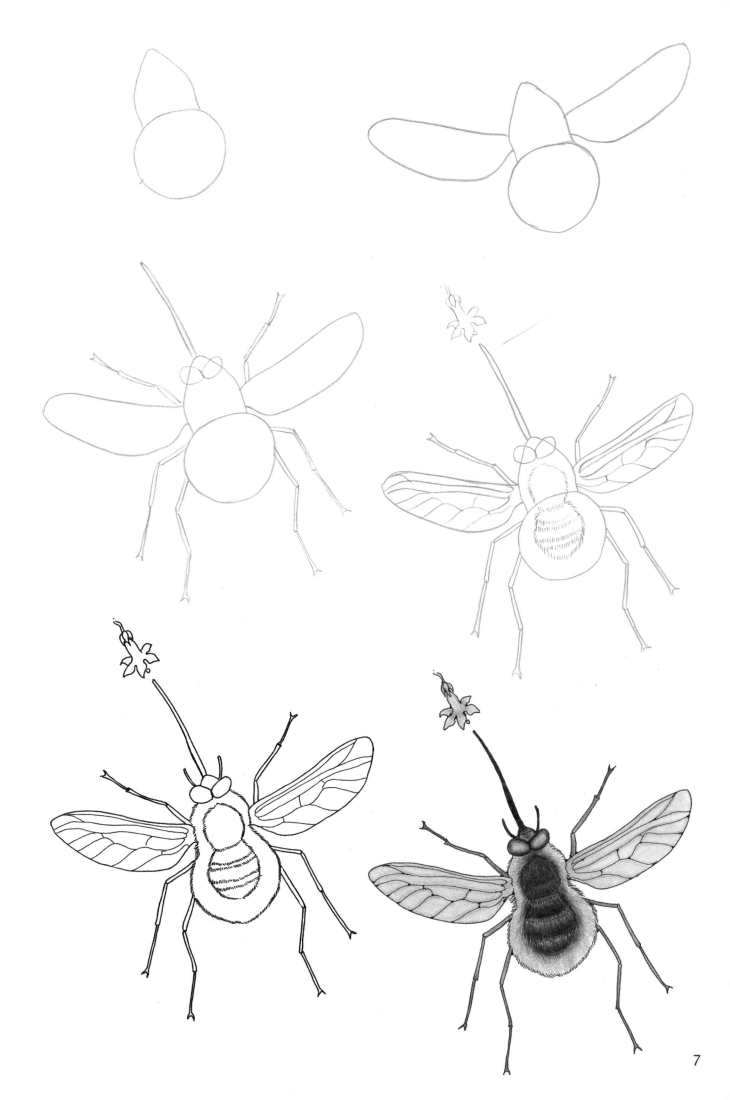

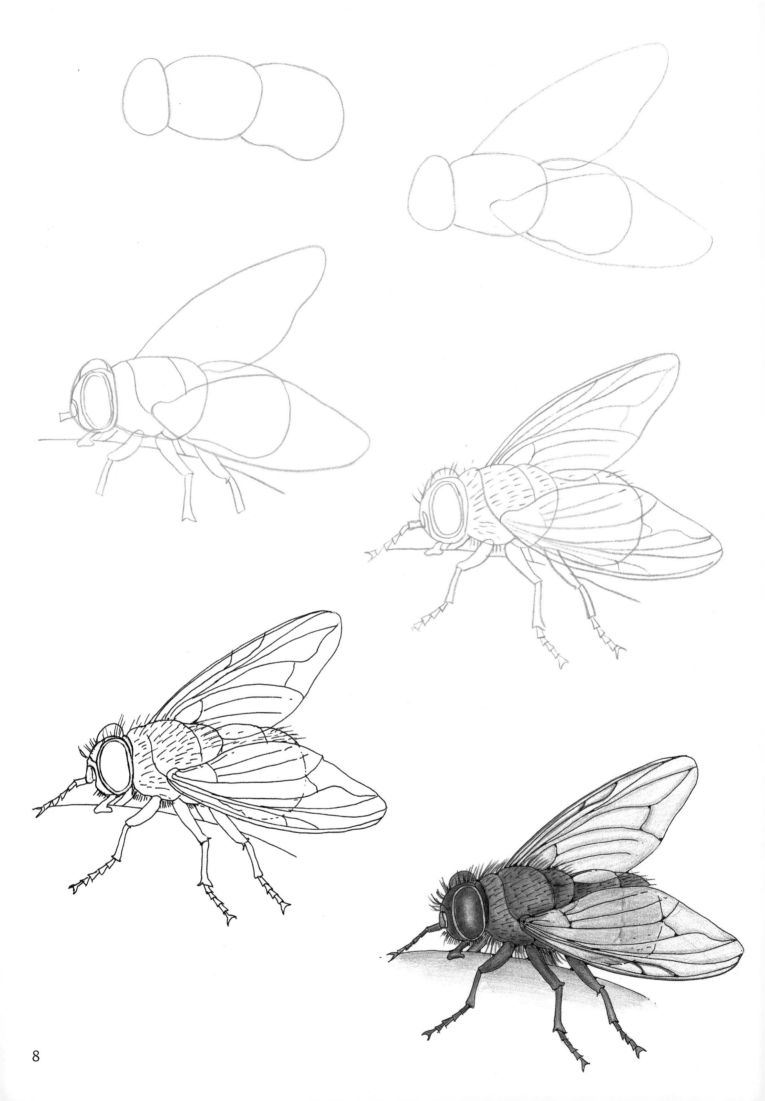

8

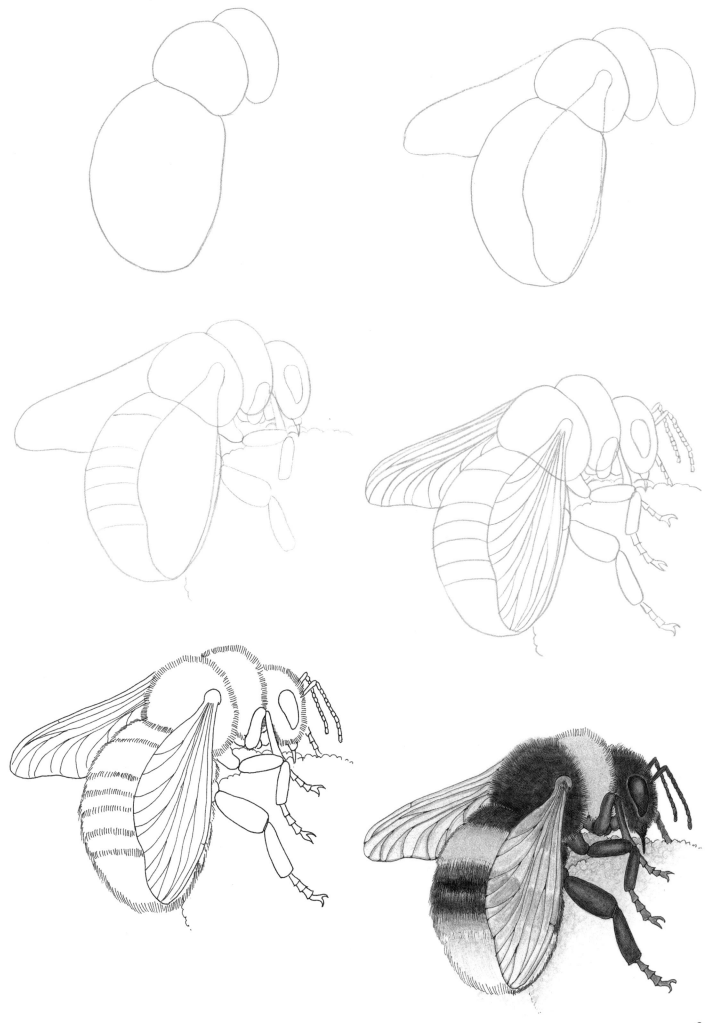

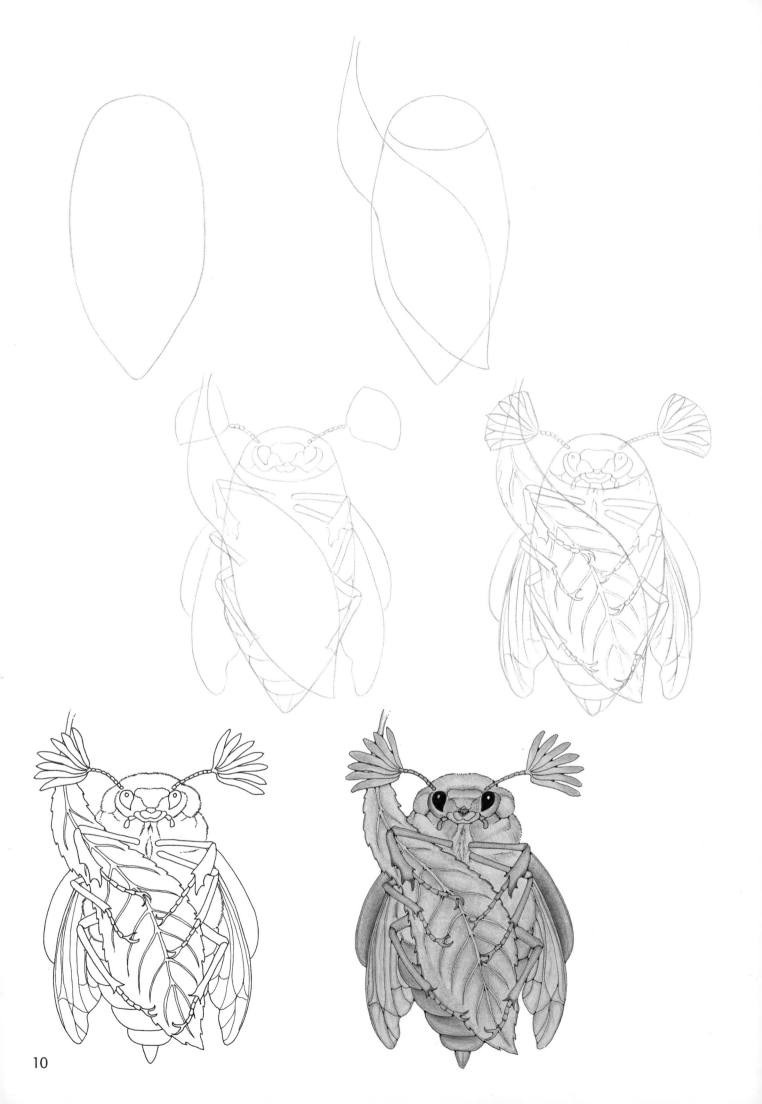

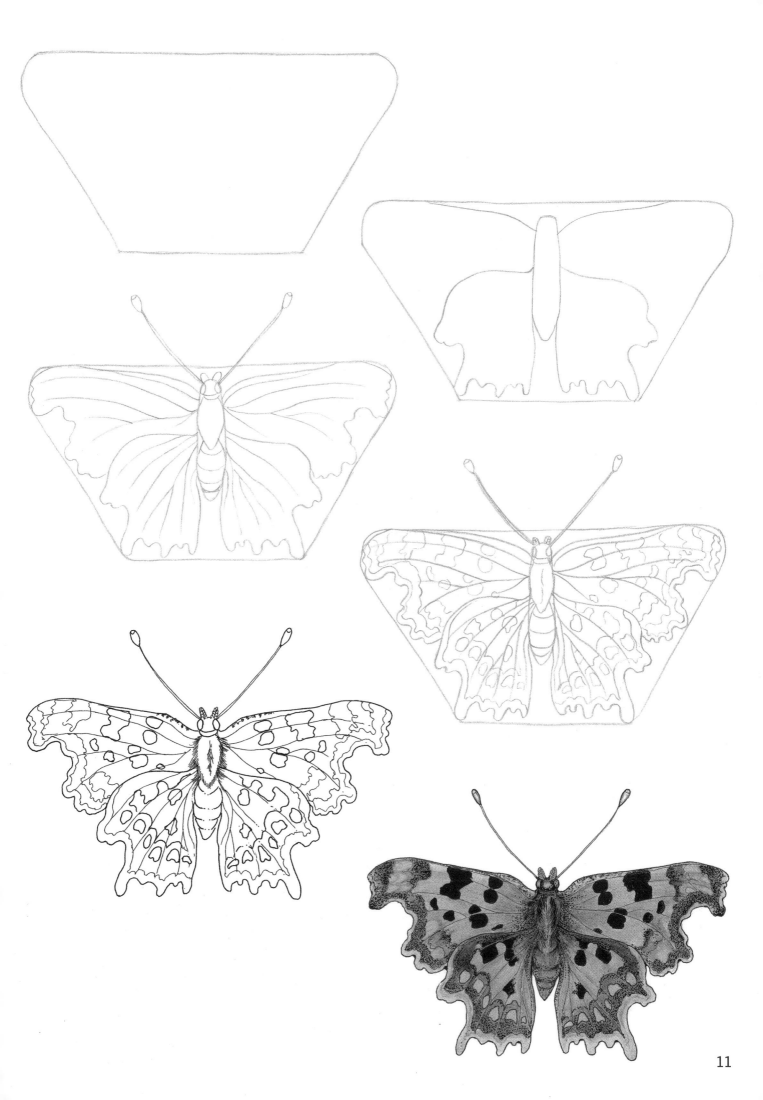

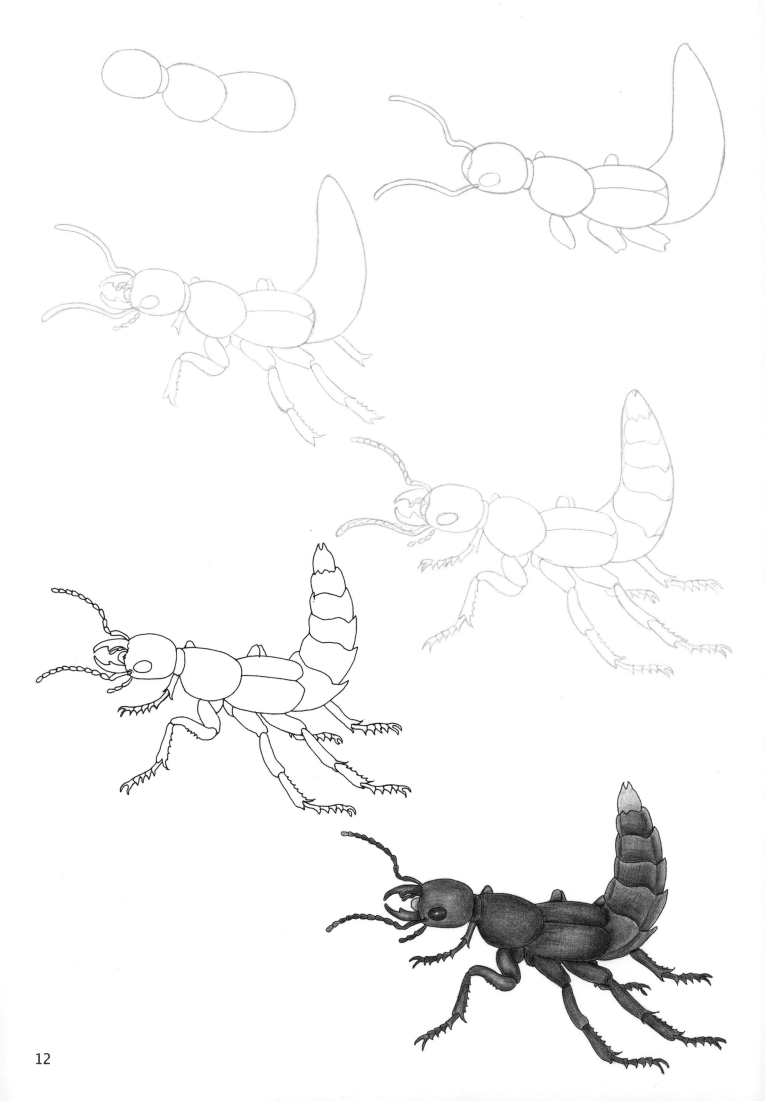

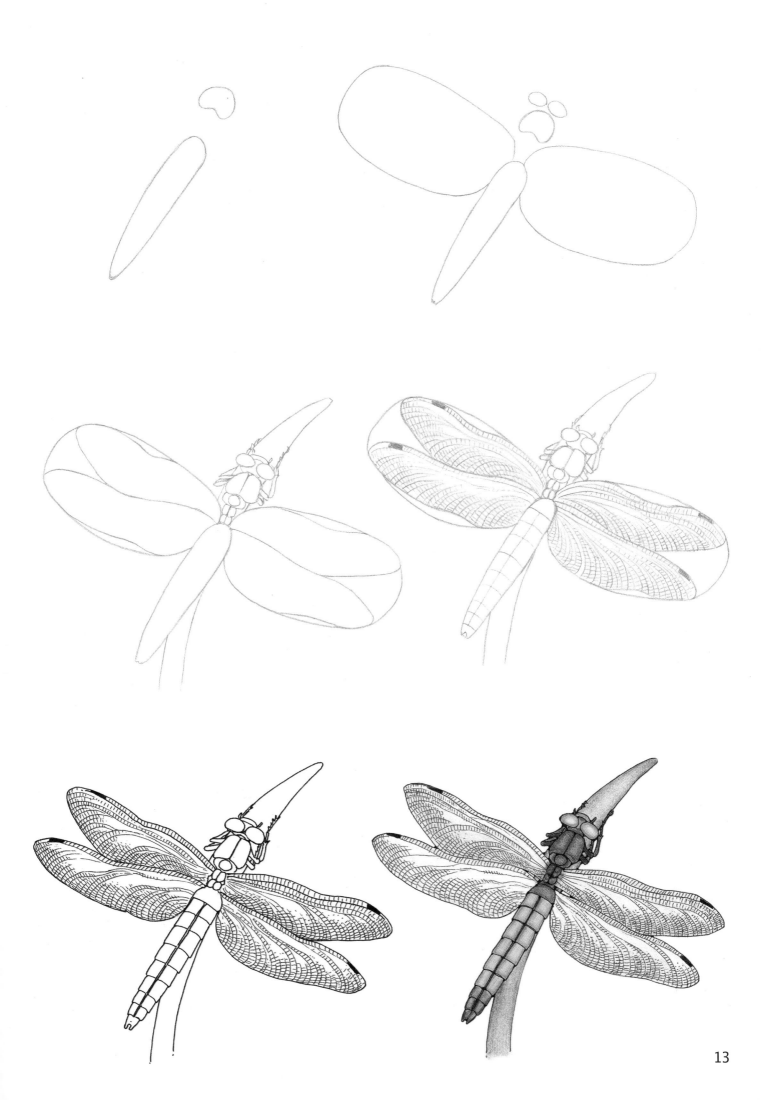

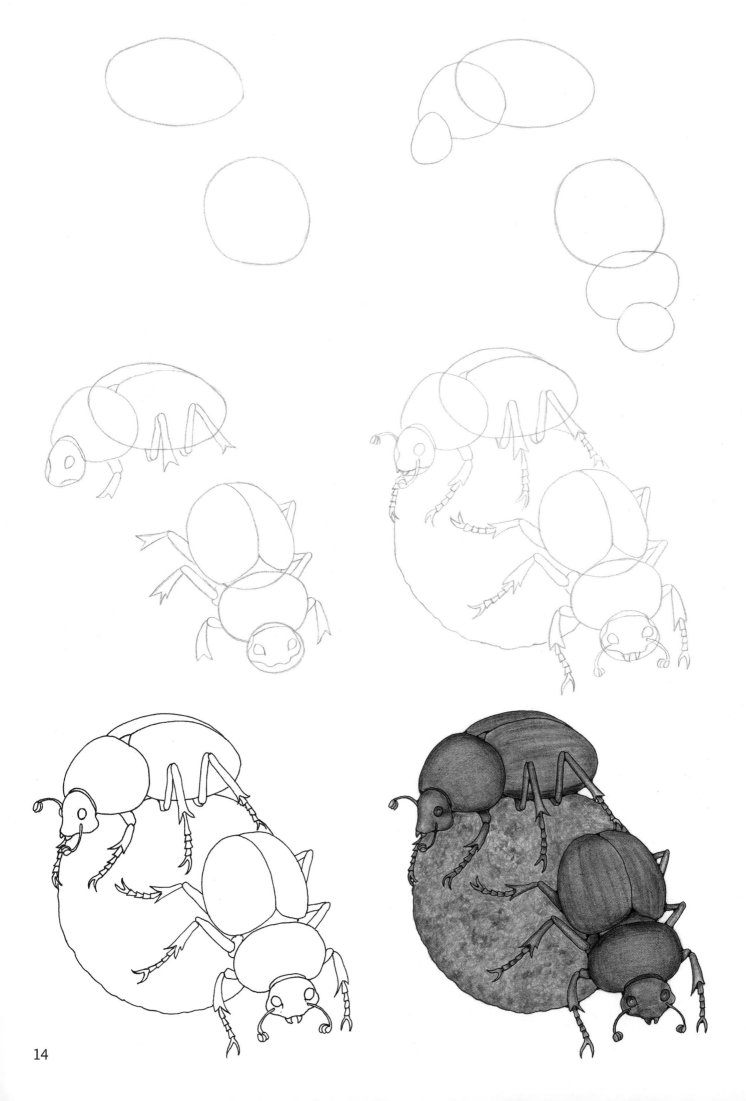

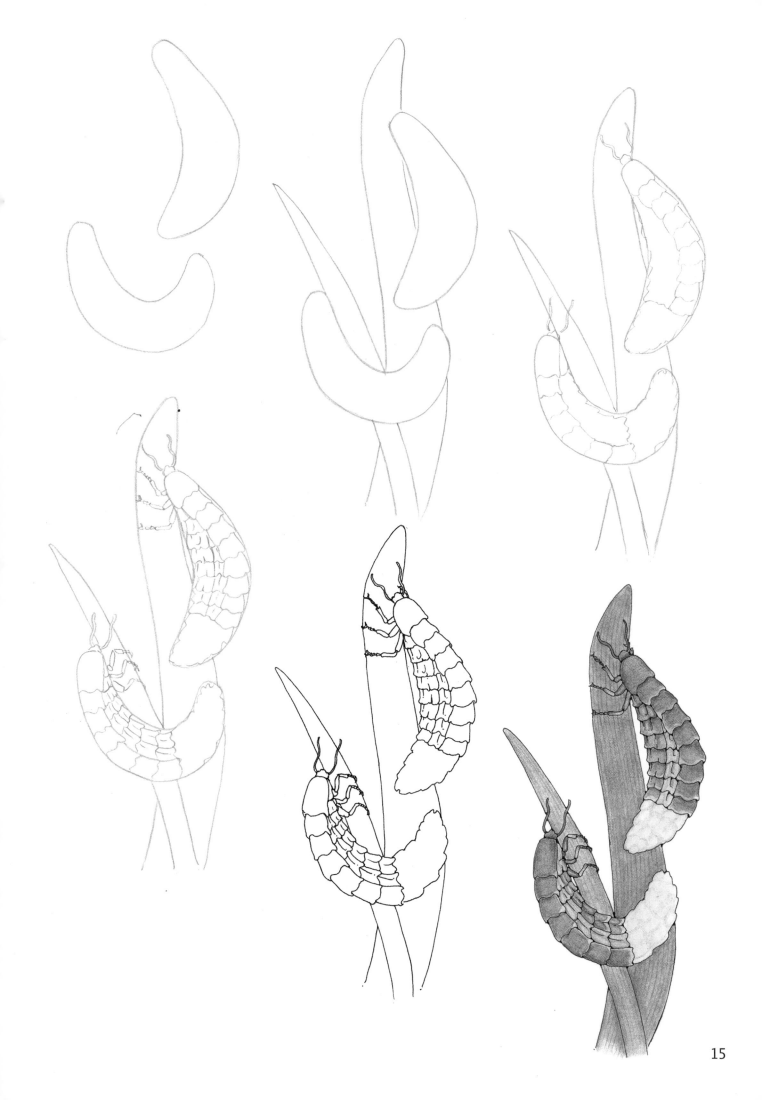

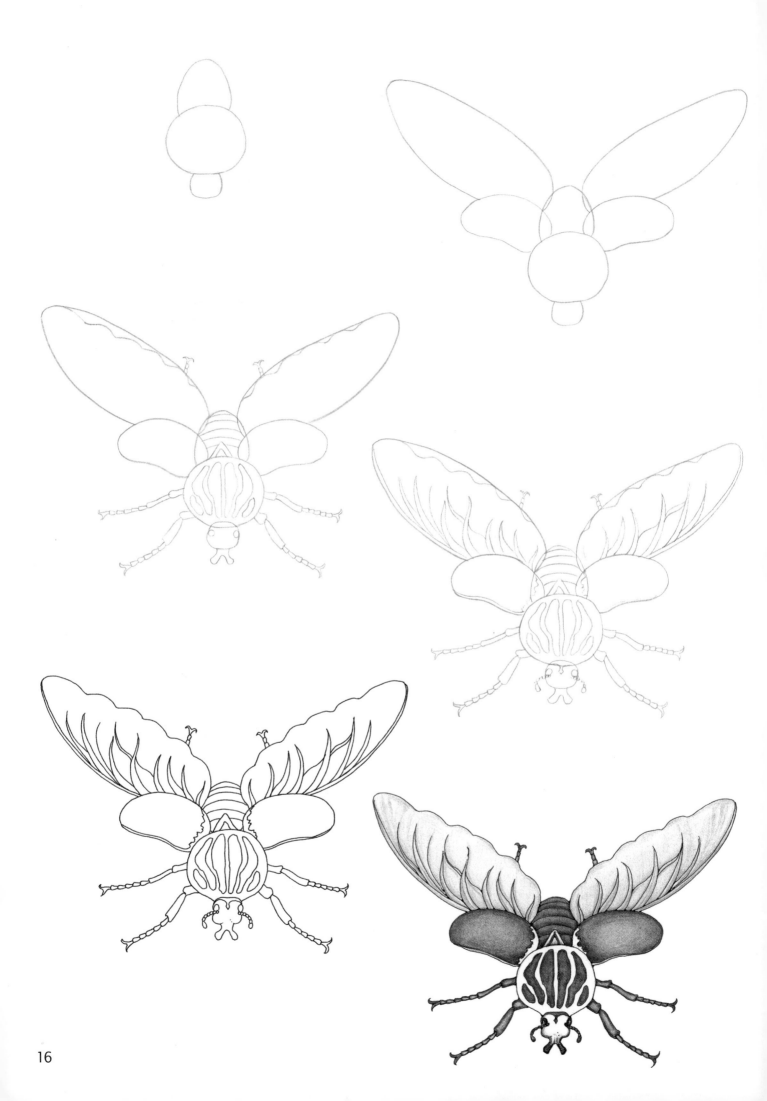

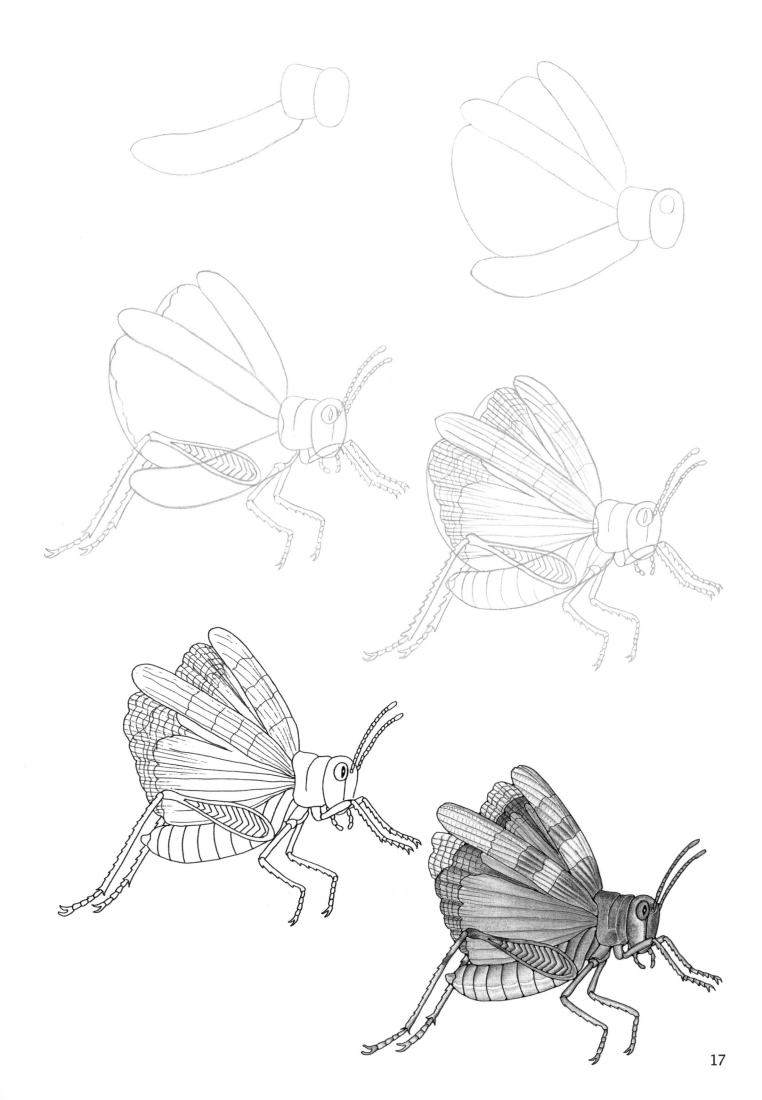

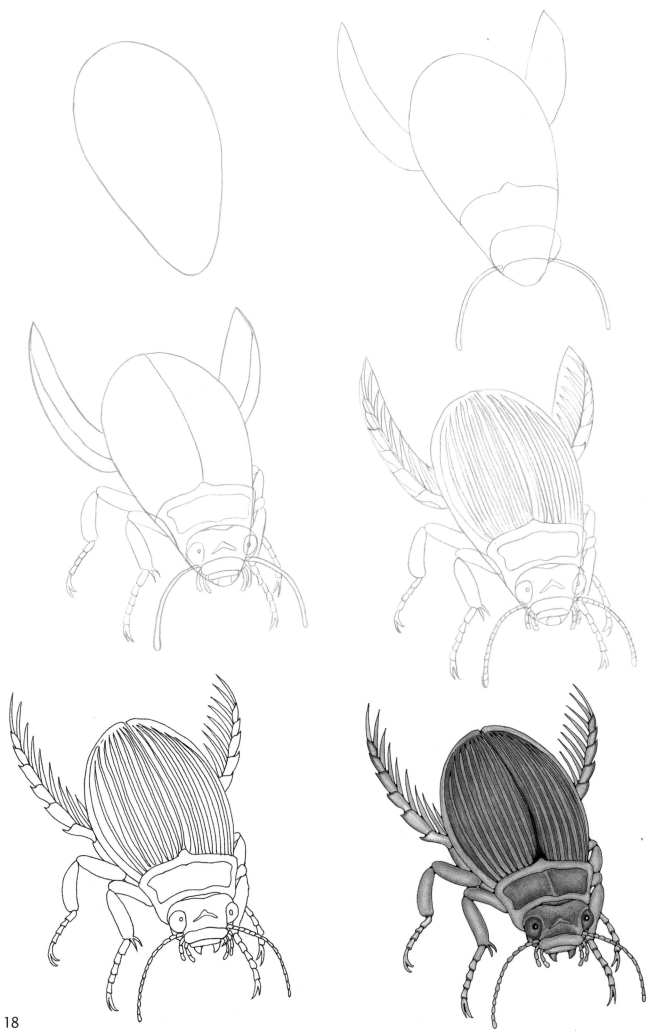

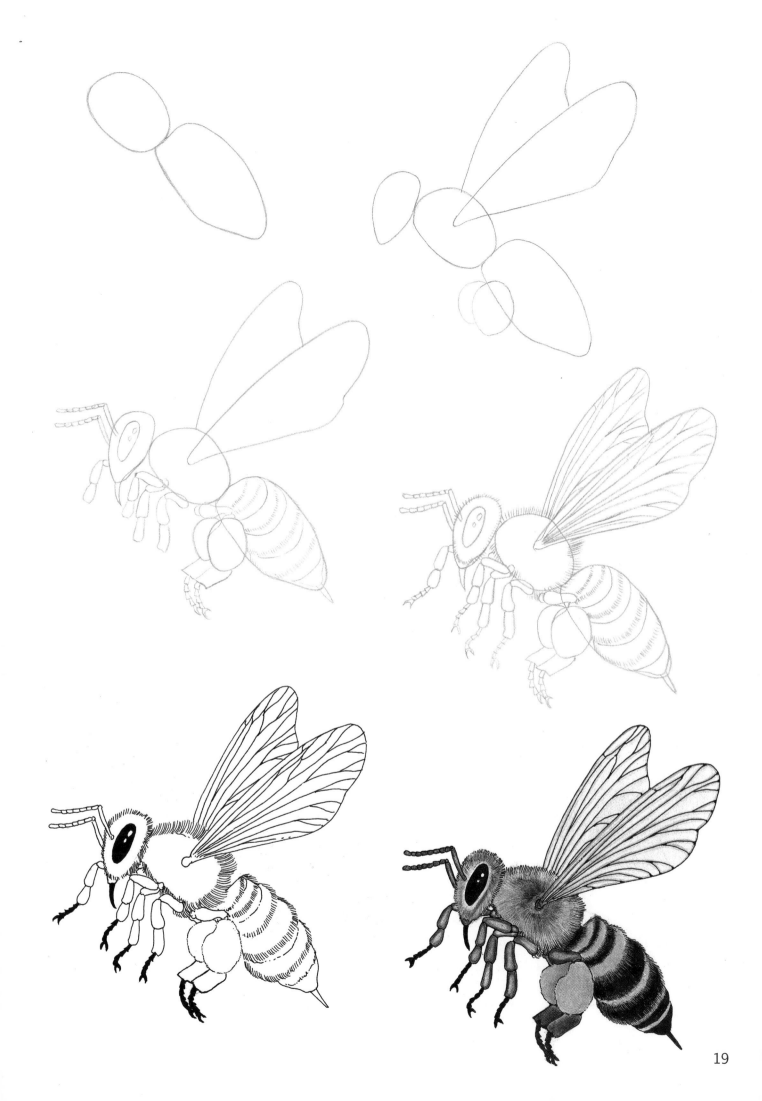

19

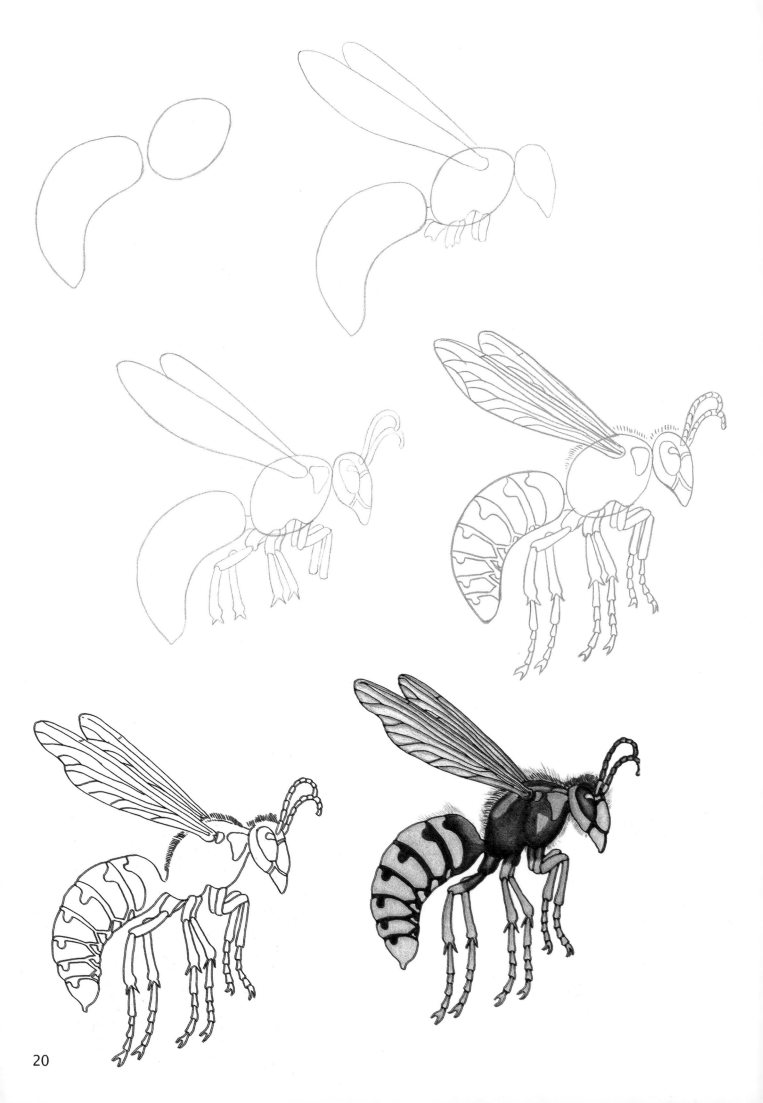

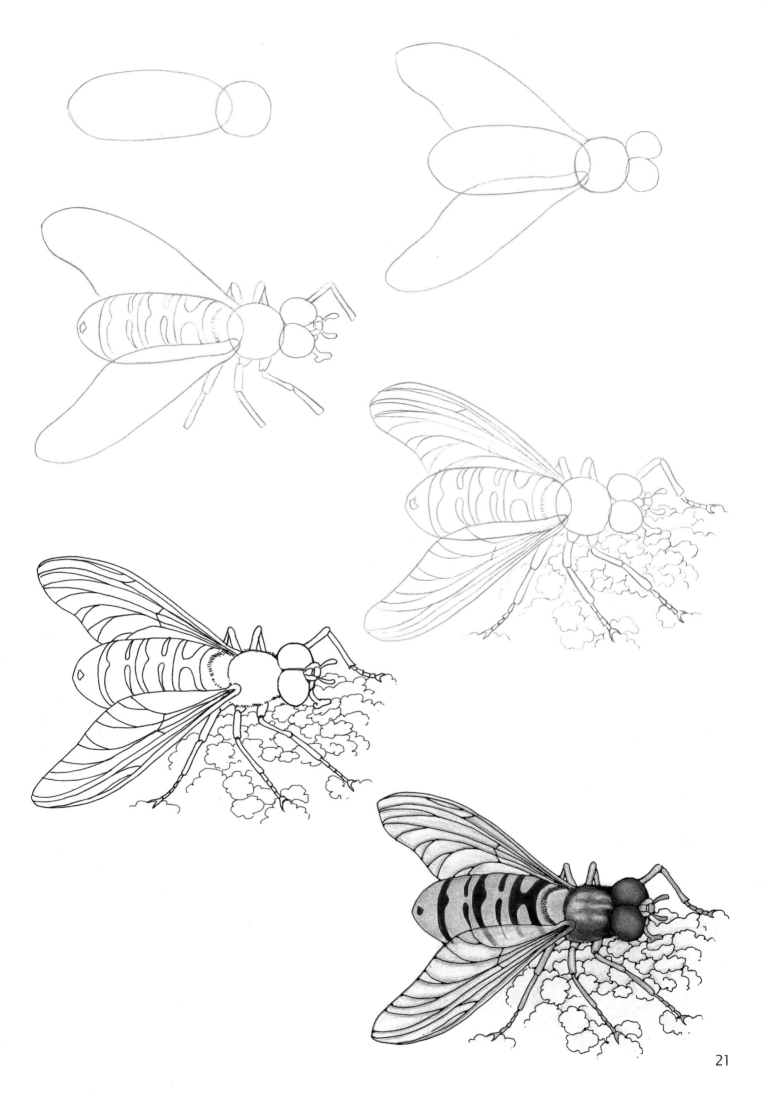

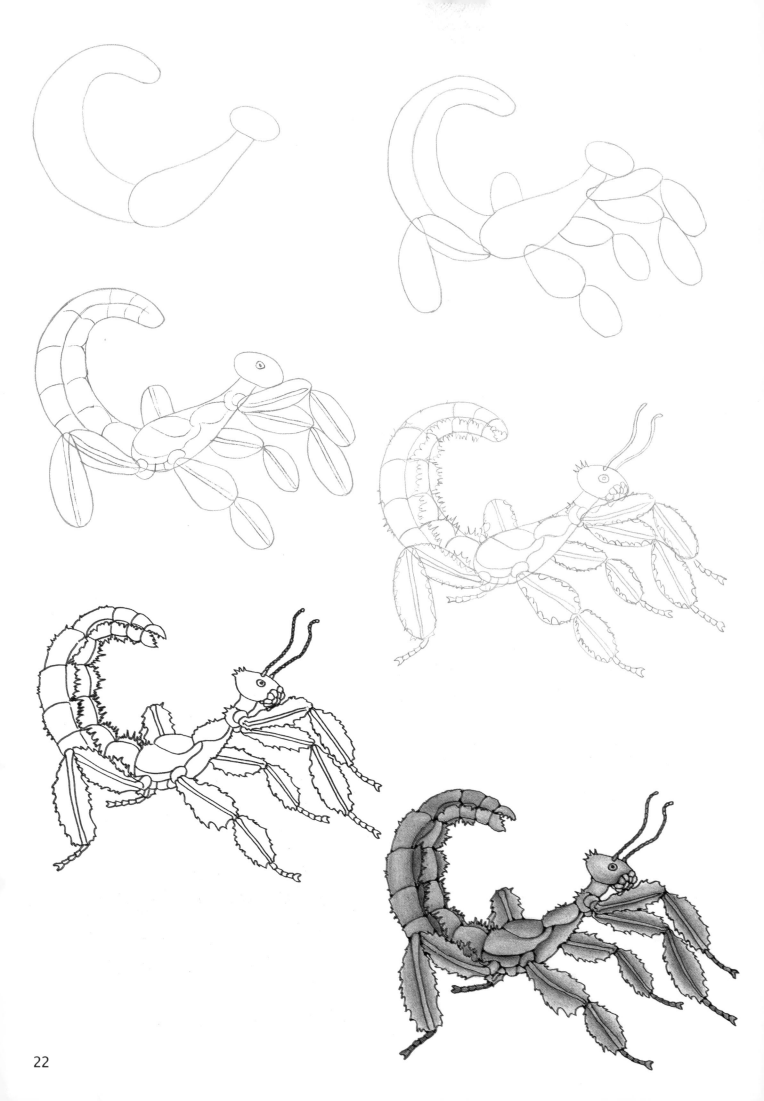

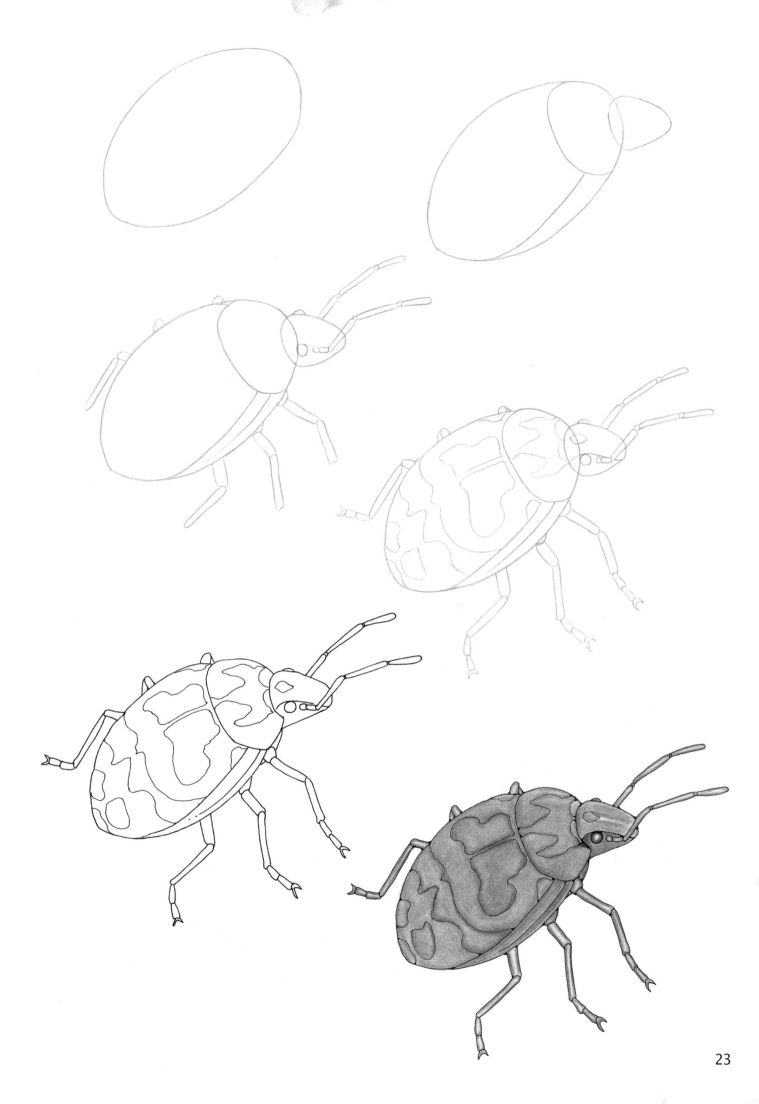

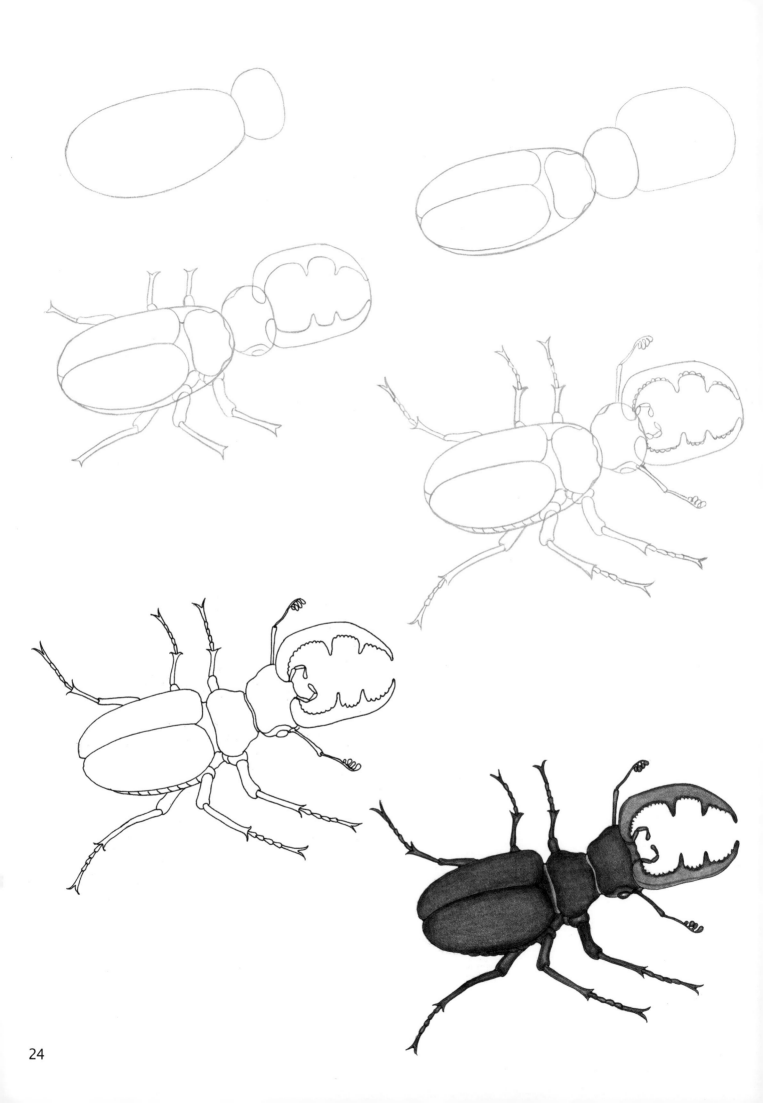

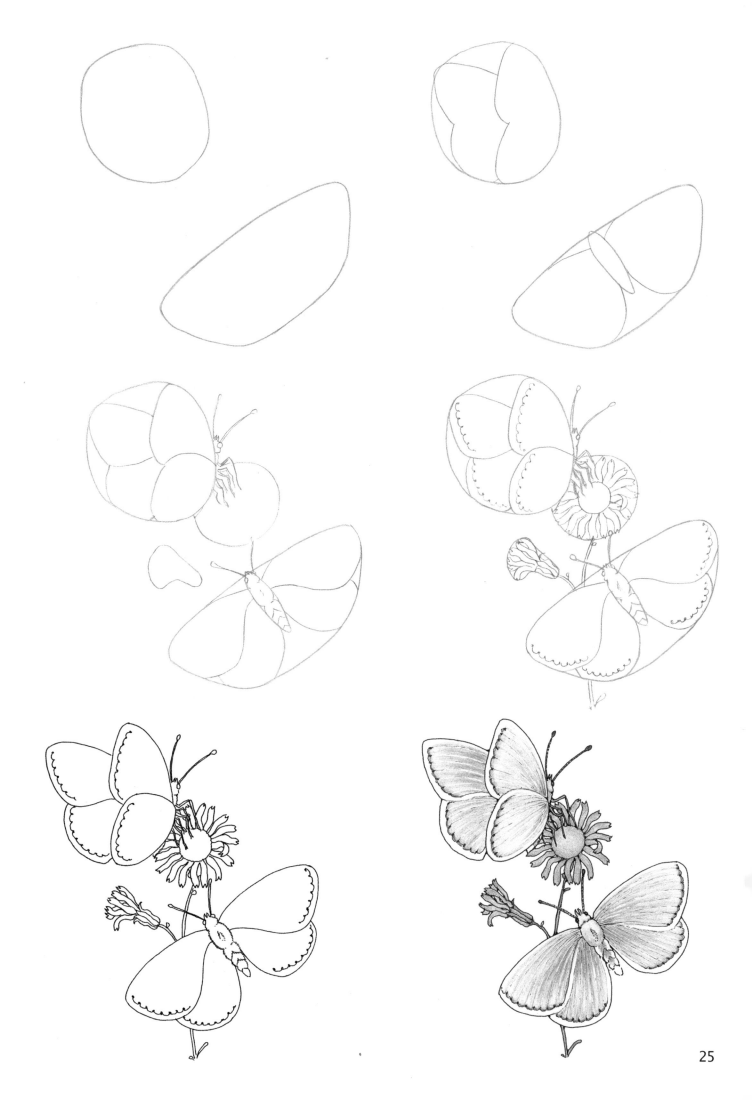

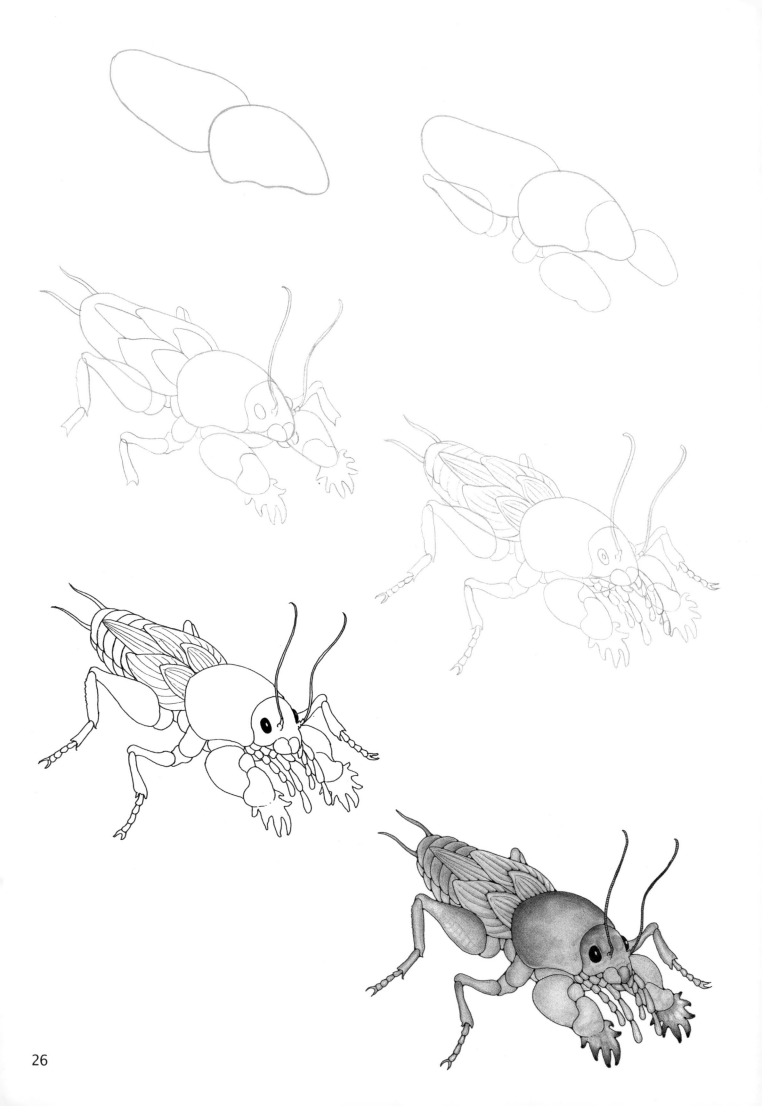

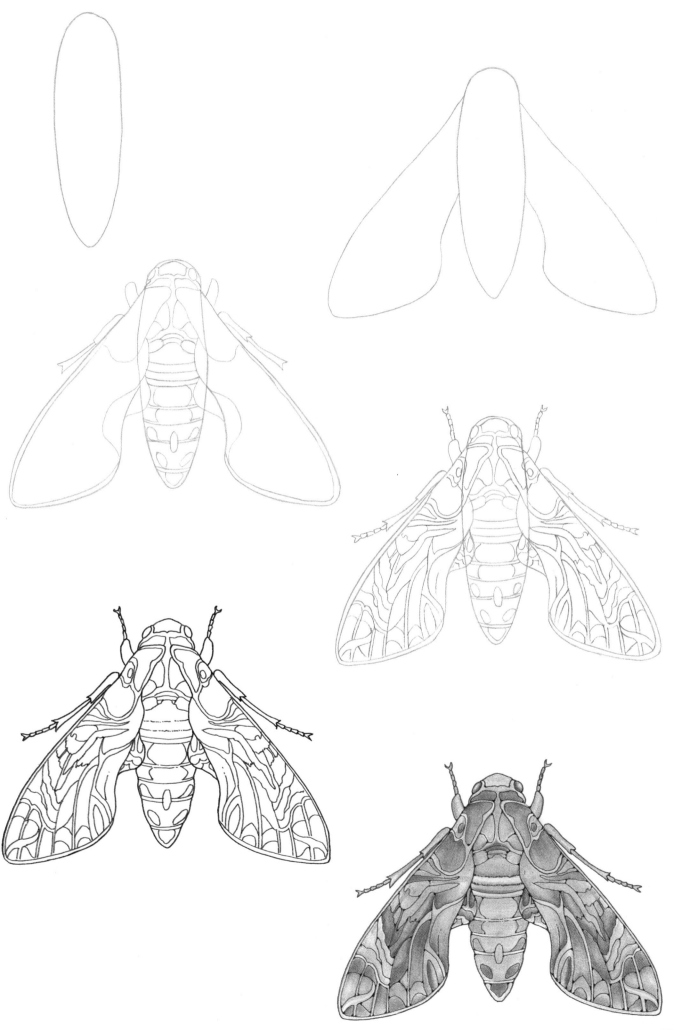

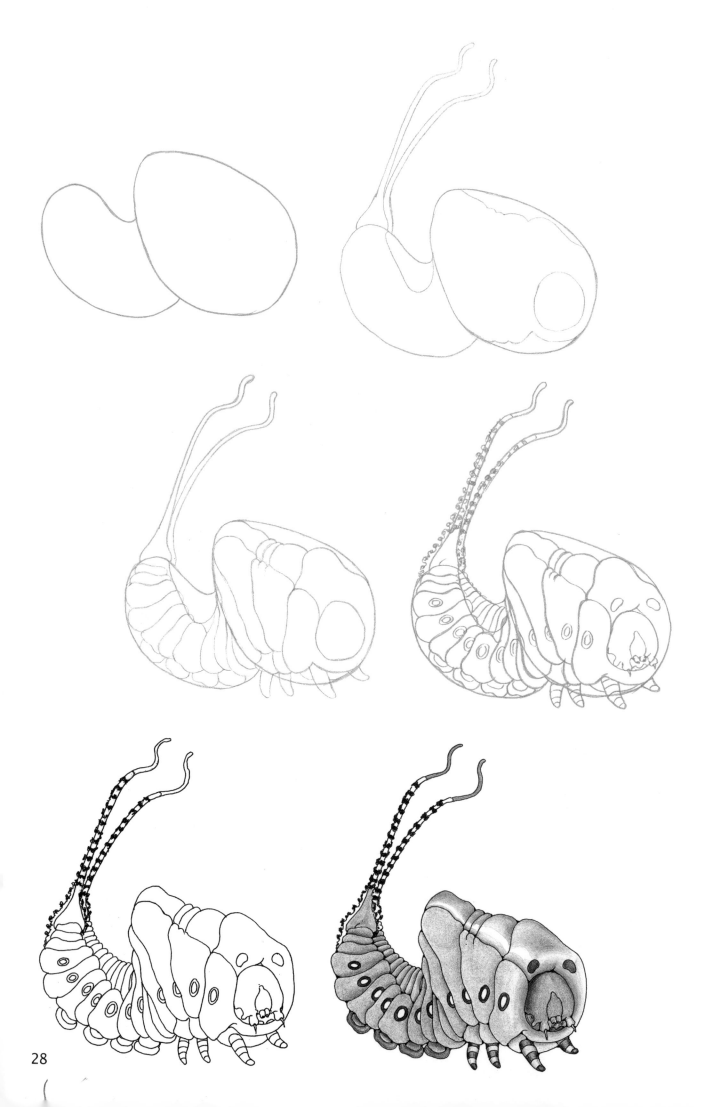

28

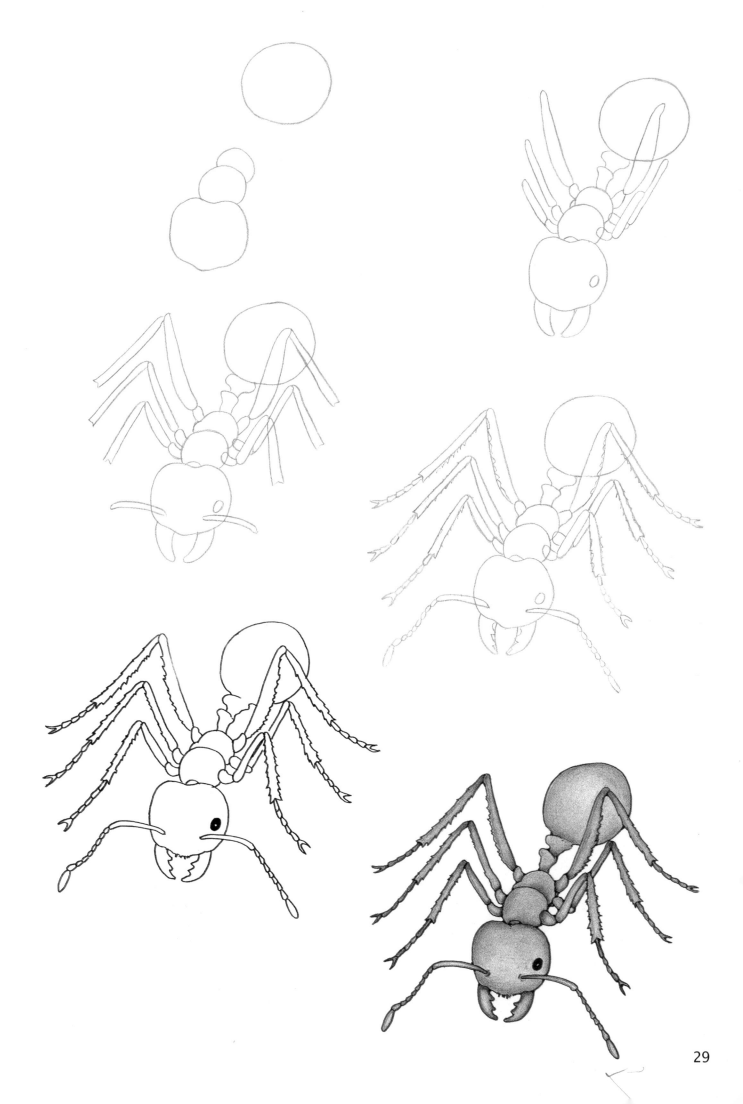

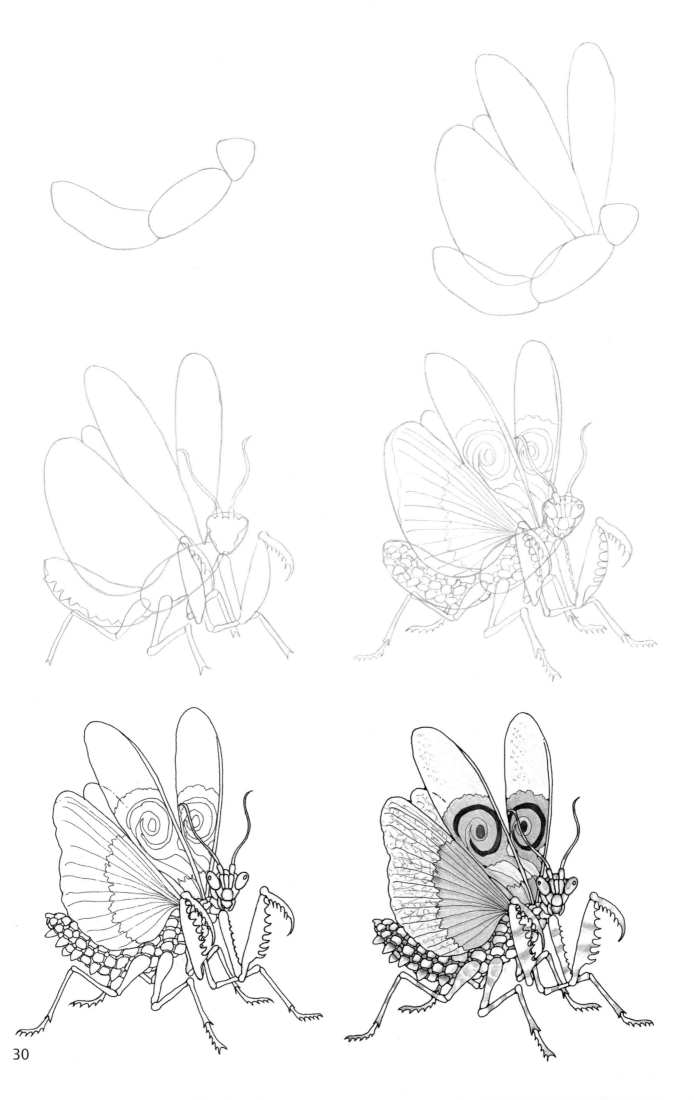

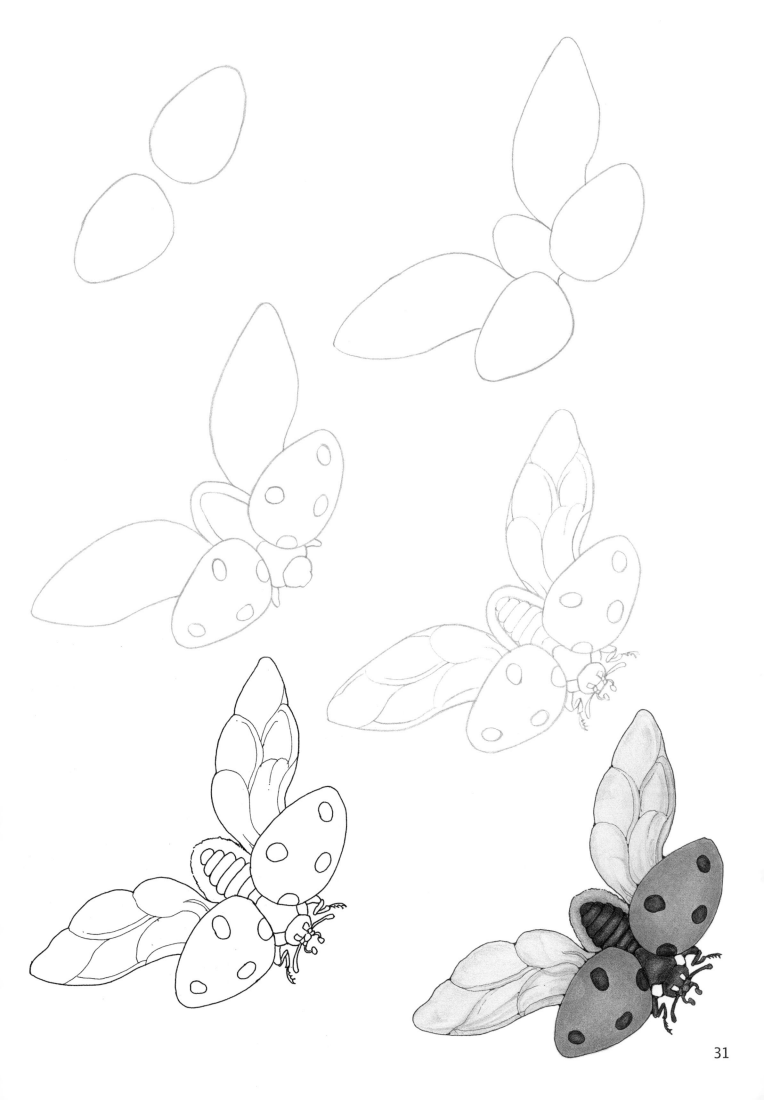

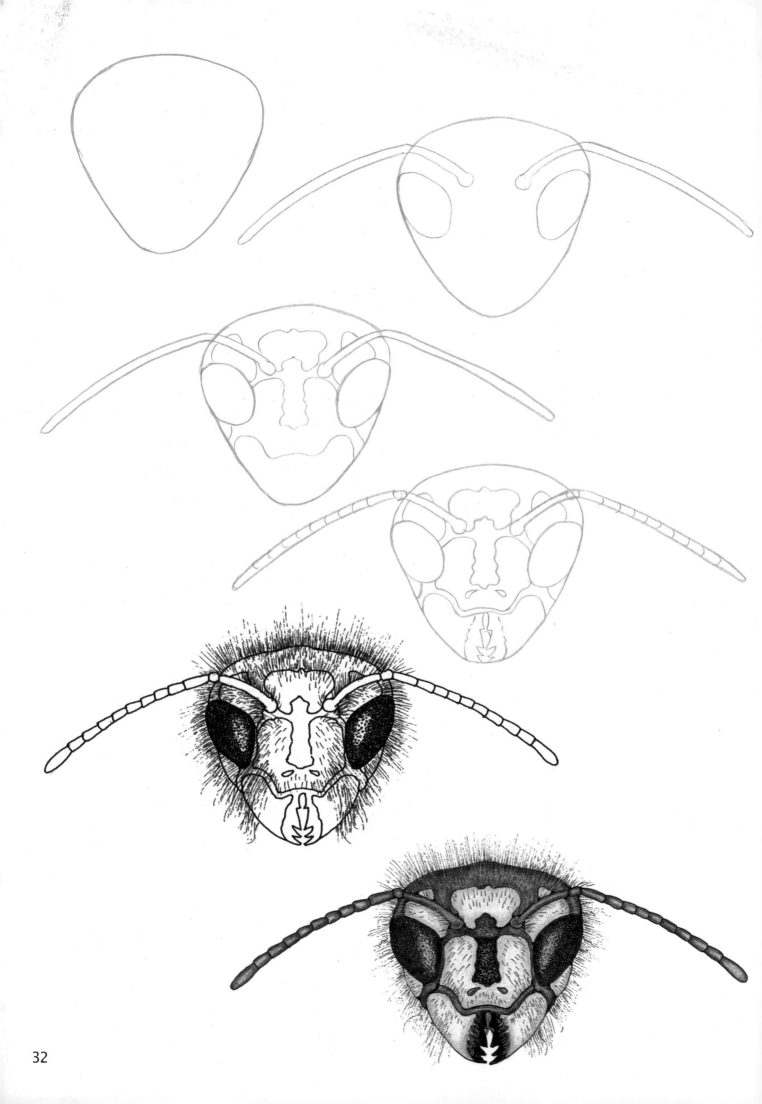